LATE HUMAN

JEAN DAY

LATE HUMAN

ISBN 978-1-946433-83-1
First Edition, First Printing, 2021

Ugly Duckling Presse
The Old American Can Factory
232 Third Street #E-303
Brooklyn, NY 11215
www.uglyducklingpresse.org

Distributed in the USA by SPD/Small Press Distribution
Distributed in the UK by Inpress Books

Cover artwork by Cate White ("The Traverse of Man," 2012)
Design and typesetting by Don't Look Now!
Text set in Linotype Sabon (Jan Tschihold, 1967)
and Berthold Formata (Bernd Möllenstädt, 1984)

Books printed offset and bound at McNaughton & Gunn
Covers printed letterpress at Ugly Duckling Presse

This publication was made possible, in part, by the New York State Council on the Arts
with the support of Governor Andrew M. Cuomo and the New York State Legislature,
and by an award from the National Endowment for the Arts. This project is supported
by the Robert Rauschenberg Foundation.

CONTENTS

LATE HUMAN

Your type will soon be extinct.

—*Ninotchka*

WHERE THE BOYS ARE

Deadpan

Clit clat clit
Your tongue shall be slit

Think of it this way.
Two husbands vie
for a place in one nice lady's limousine.
The sensitive one aces the bar routine
where the smear on the wall
means dirty hands
 Don't make me
tell your poker face
so long farewell *auf Wiedersehen* goodbye
It's a rough life
for a bird on a plane
sans cocktail

Masked I go forward
Naked I withdraw

[Who am I?]
[[And for what?]]

Cuckoos don't sing this month,
They only sing "cuckoo"

Minor imbecilities are cut short
when the anarchists arrive
from outer space to tell
us how wrong we've been
to date Dear comrade
Come in here, we'll say
and clean up this mess
then go get the fat crop off the glowing stalk
and eat, eat!
It's a light enough meal
but the quarrels of the squirrels
make getting it dicey

Crop circles are in fact nice places for fooling around
if you know how to swallow quietly
We can address this problem only indirectly.

Tread on a nick, marry a brick,
And a bee will come to your wedding

Heat rises off the parking lot and leaves
shift slightly
desultory in the event
outside the agricultural college
where we talk
mostly about work.
Minutiae reconstellate.
Settle down.

Meanwhile Tomcat and Jerry slurp
at the graywater bucket
waiting on your free stroke.
Who's the straight man
in that duo
now? Decimal or coelacanth?
You or Descartes?
Is *now* in fact a good time?

These are only omens on the way to school.
Fossils.
Not one pretty line.

Are you spin, sprout, or blackout
Fading in or falling out?

It's like you're from the fifties
when they were king, queen, jack
and all the other numbers flying
in simulation
Why have they set us knaves to hauling
the embers of other members? Amount,
amount, O fellow fur-bearing creature;
live up to your college degree! See me
cross my arms above my chest as
the tabernacle drains
and a blackish engine rips counterintuitively
right to left a thought
crossing a private miner's mind
precedent to a cough

and slow to return (Ahem to the dirt!)
again

It's not the cough that carries you off
It's the coffin they carry you off in

Stay calm and carry on
as cooler weather makes its entry into Eden
Wrap up your junk and cover your face
we're only called "Sir" for a season
in inference
Item: Is it strange we don't yet
call a spade a spade
or refugee an angel?
When did the horse come into the picture?
When his cocked hat and pistol?
We're on a train all
headlong for the tunnel
aleatory, alimentary, and ailing
That assonance of stag and jackal
spurs joyful release
in the darkening plain of public domain
on paper at least

Ip, dip, dip, my little ship, sailing on the water
Like a cup and saucer. But you are not on it

Who dat say who dat when I say who dat??
(boomed into an island phone box
ashore once more
after one hell of a blow)
Can we blame him whose lingo dates him?
Can we blame Nixon for sitting up on his heels? So
Cagney might whine
Why you—
Come out and take it, you yellow-bellied *rat!*
Is it not your business to occupy *something*?
Mine's a hunky dory
until it gets lost in a following sea
allegedly
and we have to go to Gloucester to get it

What's your name? Elegant pain
What's your number? Cucumber

There's nothing new about the sign on my back.
"Take care," it says, "I bite."
Yet I climb every mountain
with the mother-daughter mountaineers
try hard to ford
the stream nature plants
epistolary
in my way
without gnashing.
A mile is long
as lips on dry leaves
though the pain in the face-up position's
a little like a tease
to one who
pricks her own embroidery—
Wind the wind around these please
but first unfinger.

Then unbe.

Undersong

Such an evening
If you're into it
Falls upon its hands
For an élan that no longer applies
Every thing
A parliament of lines
Queerly gathered
At the Water
Table
"It may have been a dream [or drain]"
Everything
Glows until dull
But definitely I slept
There under
A magnificent tam
Every man
For himself
Soberly speaking
Of the devil

So you're an evening
And into it
Up to your hands
And knees
The Plan
No longer flies
In the face
Of the thing
Of all things
Gathered in a net at
The river
In
Definitely a dream
When I took Charles
By the hand
To see the maritime productions
Of my knotted
Father
Long-haired and often
Asleep
There under
A wineglass elm

Slant habit
An evening I've fallen into
All thumbs
Up to the itch
Of further stuntwork [research]
Corrugated
By teams of queer
Balladeers
Hugging along a watercourse
Of course your canoe
Transposes the aloe
Of canapés under canopies
Filmed trashily
For "posterity" if not
Posteriority
Definitely excited
As so often
By the discovery of
That sundered species
The ass
Dressed up to look like
Your beautiful dream
Of matter

On the limb
Of light
Into late so
Into its transit
Free and public
Speaking formally for
Me in milking a stone
The wall cries
I am made serious
Solid
Attentive to the beautiful
Punto in aria
The shape that becomes a number
Cast up by dull twins
If ever oh
Writer or secretary or guide
Pino in Shipibo
Among spirits paired
Boasting
And precision to the delicate
Dull tongs
Of a hummingbird

Evening snuck up
On fallopian hands
For the fruit
As soon as it moves
Becomes a line a
Knot as in cat
And mouse
Of Napoleonic naval
Battle
What am I saying so
Particularly?
The clumsy hook
Finds the happy loom at home
In handiwork
Goes on for nectar
In the world of peanut
Butter and
Hum
(Symptomatic)
I knit
To be done with it

Evening smoke sucked
The rolling stock
Of clouds
Over the gleaming race
Track so we weren't
Revolutionaries
After all
But shit
For brains following the line
Of any symptom
As parents of birds
Who do as they please
Eager as beans
Over hill and dale
Following the bell
As I said the line
Of any symptom
Connects the dots
Of which you alone are author

I could tell you weren't into it.
Night fell.
Clouds exact their toll
A set number of smackers
Roll of fuzzy dice
Over steaming plate of rice
Why indeed
Have I brought you here?
To hear there is
No watercourse near
The eggless overpass?
It will have to be imagined
(And not through any effort on your part)
As heartwarming and productive
A greedy duck
Waiting to cancel the cod
From the menu of all enhancements
Try always
When you look at a form to see
Not a warning from your heart
But a dunce
In a luminary's hat
Waiting for a table
On which to get serious about
The liberal
Of the species

WHERE THE BOYS ARE

I did something very different from what I would do if I concentrated upon a study of the adolescent girl in Kokomo, Indiana.

...

The life of the day begins at dawn, or if the moon has shone until daylight, the shouts of the young men may be heard before dawn from the hillside.

—Margaret Mead, *Coming of Age in Samoa*

I

One can only wonder
where the boys are
 and *why* they bother
to sleep the sleep of barbarians.
Dogs of the sun
bracket what in their wake
we accrue
 without allegory
(see murmuration)
in *who's to say*
 and to whom.
There are mysteries
and there are riddles.
(Preceptors, quacks.) Of these
the timid chuckle gentlest
into their jabots
as the big guns jet
 slap-happily
into the sanctuary for *Homo erectus*.
One can only skim then
into the path of the coming wave
mimulus answering by species name
lotus facing into the swell
 of bikinis'
epoptic unsecrecy
and the band won't come on until later
when rollers pound a beach
with a young Helen Mirren naked on it

II

... and *when* do we get paid?

It's true, I never take you anywhere the other boys have been, though there's a party in Dogpatch almost every night.

We tried not having jobs, got our eyeball massages with a relief bordering on hysteria, the metric of which resembled the skyline of any eponymous city (Oklahoma, Sioux, Sadr, or simplicity itself) expressed in a painting of sand.

> But I can't read and you can't either.
> So it's all scratch.
> Hence my bonnet-*cum*-headwrap.
> In's in; out's out.

After hours on the way we continue to squabble: Who'll take the first watch and who the last? Then we climb the ropes to the top of the hill to score.

See over.

III

The empathy of nonidentity
 could be taken for friendship
among monopods
 not that they would call it
such as carries a ball through the air
 under shadow of hawk
before hawk wheels in
 to the open
palm of one morning
 waiting for a subject.

 Gone now
the crisis of boredom
 laid at someone else's feet.

IV

How many precisely?

One for the end of the chorus, *huh*.
One for the soldier of fortune, *huh*.
One on the run from the mouth of the whale, *huh*.
One the straight man, one the scapegoat, *huh*, *huh*!

One for the road.

Take this hammer.
Send it in search of more hammers.
The zeros on the ends of future days.
Do their best merely to confirm.
That the big fish staring me in the face.
Is not the first line of *Moby Dick*.

V

If blue continues
one can hardly pass
unnoticed

by the somewhat dead
snake in the grass
a form

of freedom academic
to a nitwit
who daily contracts with herself

to inhabit a fiction
without sting
We should be so lucky

to pass without incident
under radar writ large
on smaller taters

When the wasp takes up the position
eager to distance itself from pain
His Eminence

delights in
"arboreal being" as,
being low to the ground

she can hardly pass without regret

VI

Are they striving or just getting off? I hesitate to guess, knowing the dogs of my father's boss.

It will come as no surprise now or ever that we have lashed the boats too tightly together—See, one droops as the other rises, and while the sisters see to the jelly the workers ask nothing much in return for their labor becoming more and more convinced that my friend with the poker face turns it square to the loop at the end of the pension, the humility quotient I lack, or something for the free crows to go on about

VII

"Island Corn"
 (is all I have to say).

Voltaire himself attempted *witty physics*
 with a whiff
having wrung the last from a jug of such
previous to expiration
The roughneck likewise
sniffs up his sleeve
 at *monsieur le docteur Ralph*
out for an optimistic stroll
and a gull gulls Gogo to go fight
Estragon's battles
 royal.
Be not afraid
if you are blessed in this way
by the incense in the censers of the censors
or their mothers.
Take it to the top
by way of baggywrinkle
 lower down.
Here is where the clowns *live*,
are not funny.

VIII

Until you come to the end
Until you've seen what I've seen

It's *Rashomon* all over again
For the women will report

Prolonged elastic enjoyment
In toy-camera operations

For the men in dioramas
Thinking is burning

At the edges of weeds that have been whacked
In the sacking of Annapolis by all that is great

In an almanac ropy in retrospect
Having sopped up the mess

Or stopped a door with a thud from closing
So the Children of Corn may sow their seed
 absolutely certain
That the longer a person remains unsexed
The older he or she will live

To apostrophize

IX

Door shuts;
kids can only take
adults for operatives.

Bird hides in hedge—
nervous
business interruptus.

In slipstream's silk
the contraption for love unfolds
on a map of the world

hotspots pinned out
and numbered.
Whereas Bond's got his name

pretty much
tessellated,
somewhere

you can still hear
corn grow (tassels) and the worm
turn. *The Thrill*

is Gone. 1969.

Where is Brünnhilde? Where is Siegfried? Eating mashed peas in a genial dreamtime by the falling waters of courtesy? It came to them to harvest their tears by the bushel basket after watching the films of Kiarostami, who, as it happens, put the flicker in their faces. In his epic *Part One* is naturally followed by *The One Who Came Galloping After with Something Stuck in Her Teeth*, rolling a little ball along with her pet Spot, one solid horse. But there was insufficient grease in the story, and so, he said, Don't go there. Just make a tear appear and follow the light.

Who put the soul in the body? The body *eats* the soul! Nor should the balls be symmetrical or in any way equal if you want children to juggle in future. Let it be said that a rising tide floats all balls: tidy vessels for one bloody nose, one syncope, one fit, one big talk—and that's only half a regulation set. The subsequent luncheon is not a meal but an event, teeth grinding to stubs over the grit in the cake. Our thumbs may recover from the crises of the gods. Our tails have a habit of preceding us.

SOJOURN

(THREE OBVIOUS ELEGIES)

In Search of Lost Time

Let's not cry over spent rods
make a mess of ourselves

What is paleolithic after all
but a horse of a different itch?

If anachronism's the joke
may we make *Spem* our song

in our march to clear away the limbs
then ivy

Too many questions
irritate the baby

on our way to the margins
of the forest, where the stars of our others

are waiting. They have the knobs,
coins, buttons

and we line up according to this system.
At HO scale the bears

are hardly threatening, though in the end,
bears.

Can we make it work for us?
From a distance we see the bridges burning off their trestles

Nearby, the tables turn
in the snafu over funding

We don't really want to engage
at the level of the line

left hanging
that we ourselves come to resemble

like the train whistle
slicing out its thrill over the countryside

(But) Symbolism began
when rock lay too heavy in the hand

so had to be thrown
and we came to prefer

the presence of singers
in our serious-minded sodalities

of (endless rapid) Hezzanith
readers. It sounds logical enough

to calculate the azimuth
with the celebration of the birth

of the irritable subject
in the circle of her own warm covers

waiting for her mother
to pass the message to her dad.

But let us buy a little trailer
for our travels, get

away from starts
through planted rows

of silos, cylinders, and stills
left standing by the twister

and greet the refugees going and coming
with the hottest coffee ever

hopelessly nostalgic
for the islands in the stream of other islands named

between the gendered ends
of electrical parts potted plants

and their homemade souvenirs. We said
we'd not just be "a special condition of language"

doing covers of '80s hits as if when the time came
it would blow us out of the water

We were fallen but not angels
(We just tried not to hurt ourselves)

as the bear from all fours
stood full to her terrible height

a little confused about where to turn next
among clouds we've had enough of

By the stars
By the grass that moves We

couldn't let go

Lost Illusions

"No sense like license"
opens

on a vast little plane of hostile wonders
posited

as day or daylight
by the scrub jay and her supporters

whose episodic memory is said to be a stunning
contraption

like that cloud of a woman we never knew
where to go

or what to do when we got
there diligently copying the masters'

habits
for a few cents and a bed probably

blond or blind undecided
leaving no stone unloved

ousters questers quitters all
like butter in our determination

to never die and just go on ahead
to fever

over some soiled
nankeen trousers. Your realism

would send anyone to spasm.
How dare

the service dog
refuse to serve?

I will steal everything Old Navy has
to offer and still

come up short
in the unoriginal gargle

of the wave receding from the shore
in the rough applause of pines

we've had enough of
if and when

the wildfire attaches and
eludes us

in its rush to ruin the tiny actresses
who serve

to bring the play about
under their curls

of smoke. That's a metaphor
if I ever heard

the line of mortal sweat
you wake in

cast as duff
you can't control

if the phone's too near its cradle
to speak its piece.

The Uber comes to chase
the Minotaur to his hedge

leaving us eccentric
if exposed.

This is going nowhere.
The excess peplums (plums, pearls)

from someone else's poem
are just a distraction

How little we know
about the *soup* that is served

at the daycare center
Does it meet our needs? Wants?

Desires? Here deer are sparring
to mate

We call this grabbing at straws
with wooden spoons

but I don't hate speech
just its bloody show

of fits
when the going gets ecstatic

or rough
I can't embody anything imagined

because nothing new is really nothing known
especially when

nipple to nipple
underwater

the gift of gram turns
out a distraction—or

outright loss of function
(bowel, canal, commode)

I could take you anywhere
and yet I choose

to prefer not to
though I know I'm not the first

to exile the dog
against federal law

from the car when it arrives
to take my body to science

and finds it's all
full up

The early adopters
have won the day

in squirrels, rats, and wrens
when

were we not
shown the way

to the hayloft?
Say something. I could go on:

The slave university thinks it's brother
to us all

not evolution's
own conclusion for good

and all of us a meme
next the ear

adhered to
as the belly of content

from which it shall be rent.
Why not state the obvious?

Hasters gotta haste.
You wouldn't say you wouldn't stay

but swallowing the hay-
seed became too difficult.

How much the past has come to define
the present

when we call the clouds "Turneresque"
in the middle of a gale.

I would have to read them *all*
over again

A Sentimental Education

I don't want to speak for you
but we have to start somewhere

as half-geniuses qua crayon eaters yet
Here we are in the wetware store again

watching a many-legged creature,
red, hurry across the page

unsure
if (detected) she's before or behind.

If you begin life crying
as most of us do

it's really not possible to take the longer view
from your mother's breast

at the coast of wanting it not
to be about that

(How quickly we come
to shorten our thoughts

across a canal broken inexactly
down the middle)

If setting out rewards the coming back
(or vice or versa)

what you don't want to know can and surely will
hurt on deck, in hand, overnight

overwrought you will want to know
the exceptionality and exactness of each animal's form

before agreeing
who can use this information

against us in distress.
We have stripes.

You, beliefs. Or will, soon enough
cheek against flank

eager to get on with the lesson.
Day, in the neighborhood, begins to cool

Memory and imagination have been at it
split

into smaller and smaller
kids kibbitz

then drowned by the roar of the surf
we toast ourselves

as a species
unable to fathom its limits

and the fact
that whatever we do is useless

while the frog goes quietly
out of his jar So

begins our movement
away from the sun

and call it only just,
our captivity is our Hallmark

moment. Brothers and sisters,
the news from home

is not good. The bombshell arrives
in the form of DNA:

that Delaware you thought you were?
You're not

so much a hobbyhorse
as a kitten

whose progress is slow
but picks up toward the end

of the Thug-Life video
or clouds we've had enough of

and the cop show, it turns out,
we've seen before.

It is a ridiculous pleasure
to inhabit a new cubicle

at this age
having never got the hang

of track changes, never found the wetsuit
hanging.

Take it from me
we could never afford such luxury

so instead groom our lips
toward the neck of she

whom we love
furious at being so young

LOW LIFE

To *Mr.* H

Sir,

In the following Sheets ... You will find a true Delineation
of the various Methods, which the People in and about this
great Metropolis, have ingeniously contrived to murder not
only common Time, but that Portion of it, which is more
immediately consecrated to the Glory of their great Creator.
In this, you will see, they have not wanted such Success,
as the extraordinary Attempt deserves: For they have left
no Hour unemployed, either in the different Scenes of
Debauchery, Luxury, or yawning Stupidity, if the latter can
merit even the Title of Life.

The Author.

—from *Low-life: or, One half of the world knows not how the
other half lives* (London, [1752]).

After the experiment of the street
a blast winds a face
in its own scarf
and pages sail off
in the general dust-up
Now how can we nail
what's risible in a star rising
over a stair or
a cock on the block
statistics being what they are
nuts about
Someone in the neighborhood will anyway finger
the perp in the line-up's
to-go cup noting
nothing is everything
from genome to rice
fruit cart to counterfactual
intelligence *Now*
we're getting somewhere
—and, Sir,
you may depend upon its anti-name!

Noting in a to-go cup
the augury of momentaneous
emotionalizing we
have a day yet
left
to make it right
for our followers having followed
us into this mess
time being linear
on a circular set
the ditch inspector finds a tavern likely
for segues
from clockwise to written account
A donkey retired by a blow to the head
We will be the same
neckerchiefs or no
for the nobodies will want
to resist affiliation
It's like *bombillating*:
the bees persevere
in thinking themselves handy

We will be the same
by the wax-log fire
the same returning to writing from
bad sleep the same
untested among our helmeted cohort
getting nowhere fast and the same
coming in from a walk
by nature loved and missed
as human industry regardless
of output I accept
that we are flying
(so "going")
on credit if representable at all
The creek meanders
The revenooers snoop around
The hand instructs the eye
Our goose is cooked
But recursive is the deep dank shade
of leaf-fall

(It won't be a stylish marriage)

As human industry regardless
regards us
panhandling from a textbook
to get the feel of
our fingering weight
relative to what we undertake
or have already taken
having summoned our friends
from the public house
We have survived the double
talk of spring
when all we have is rain
What's left then of our
agency as agents?
Dinged sincerity?
Glumly we watch the house
go to the republicans (not like
we're such fantastic republicrats)
Scooting along on my nightdress
I liberate the urchin, call him infant

Fantastic republicrats
are like us denizens of a middle world ·
moms and dads cut away to umbrellas and aunts
with whom all are familiar
in the annals of bad days
when the water may rise
and one may look gently on
one's unread books
Let me just get these hose
up over my face
since we're rolling back the stock
of New Deal boats:
a cradle in that shape
rocks a nautical child
soon standing in the pool of her own pantaloons
where analogy's concerned
and the analgesic husband
like an opposable thumb
closes over that part of the brain
in need of fingers

And one may look gently on all
who tell the tale
wholly
or in parts. And all who
hour by hour
run fingers along the names
of those they'd bed and
those dead while
dancing with a mop. This
is all there is.
and all there is of this.

Yet shall we quail
with the silly birds?
whose legs in flight shoot pencil-like
from their rumps?
or wake with a start
and a stifled yell?
We'll compete for food and suitable mates
shivering while we wait
for the police to tell us
we have been let go

(We have been let go)
with the silly birds
one "Dabney" and one "Orison of
Iris" You
who see the moon in your brother's
face and laugh
you were the best present of all
encased in honey, wax, and silk stuck
to my simple socks
drying by the fire
Low tide brings sand up
a willow dell
but which is worse or worser,
the mnemonics of the thing
or meconium stiffening into dusk?
A pantleg's caught
in gorse
in the course
of readying ourselves for you
The landscape parts operatically
like pupae
in a papal state

A willow dell
is one among many silly buds
detachable inedible facts
that are not all that difficult
to imagine
like *bonhomie*—
with a name like that I
could take it all back
to Texas
in whose music we were born
to ramble *from*
though where I'd find the time is
hard to say
in a conversation a pause that
musically you'd like to fill
but can't
in the event
in the city
in fond remembrance
of a horse's mouth
and what goes on there

In the city
what goes on goes on
and sooner or later
your legs shoot out from under you
in a state of naked grace
They are there for the goose
or any coroner
or wifely duty done
It would be one
of the hours 21
were we to yammer less would tell us
why where when and how
the howl described as relief accrues
to the more or less sequential
suffering of a day
loitering to the tax
daring the axe
("A little spit and he was in")
beyond the pale of the changing shift
paid to the crow of the cock
called "Shorty"

And sooner or later
we return to the working dream
the alpha talk
of beta waving
because we had to flee political arithmetic
and did
so becoming "classic" in the end
our beautiful poverty
its square feet and features
all original
art left
as instruction
for our successors
to cash instanter
If the rich
be a barrier
reef to a sister...
if every kind of sweet
trips the endorphin response
to reading
—It's all I've ever dreamed of

And did
And did
my rush to explain
explain my hurry to live?
The massive mountain cover of cloud
moved against the idea of privately printed sand
a blast but one
in the hand
over the flow of two
in Capital
at this Particular Address
We feed and sleep
The temptation to overstate
dogs the demand
for much of what we offer
running water
from a fantastic fountain of four or fifty rivers
to your thirsty face
capitalized in the romance
of everyday life
(and here I must be checked)

For much of what we offer
takes the shape of energy
drunk by a driver
on the way to a pickup-rendezvous for
She Who
like the poorest He
that is in England
hears the crowd's applause
for the highest bidder
for her kidnap press or nab
fated finds
the going easier
head down
underground
There a man so easily abides
in his own circular tent
time being lunar or kinder to a twofer
than it is to a hoofless pig
on hind legs
about to preregister
for the auto-da-fé

Head down
the crowd applauds
from the mills to the textile gins
for example in
funicular or furnace
My orthography
gets away from me as
smoke pours
from hamstrung multistory
embassies
the tide stretches idly
across the stink
of feet belonging to me or one
of the *lazzaroni*
looking up
from last-known depths those
antinomian suspects
caught out in the sun
of Egypt everywhere
Sooner or later the square will clear

and the eligibles will stand out

From last known depths
Hugo retreats
to a shop window
and from there the glare
of an exceptionless day
stalls lite pursuit
in bouts of verbiage
You *live* here?
It's an impertinent question to one on the run

in Fixie-Town
where pastry queues
are perfectly soviet
Don't glare at me
from your shop window honey
I'm *hungry*
for the fruit of Bouvard and the
OCD of Pécuchet
—I just need to get away—
What you will
will be OK

In Fixie-Town
where I was born
post-lapsarian trains let fly
and the horns of the excited Jekylls
wax self-referential
having spelled the numbers exactly right
left on the street
where you live

Are we only on our way
to the obelisk?
To find Dull there
hunched
over a one-pot meal?
It's real: What goes up
must come back
as a man changed on a municipal map
to something new enough
though still arrayed
in a torn and likely vintage
chemise

Where you live
(where I was born)
we call everybody Baby
with only mild affectation
friction being a mechanical secretion
at this point in the story
when youth is deflowered
by a seedy old lion who just happens along
from his forest primeval
What resistance
when golden pollen
sprays slow off the axe
the axe having gashed
from anus to heaven?
And there were we
the old lady and me
wondering
the way to the big-box store
there to deflower
others like us
or a potential series of this kind

From anus to heaven
ad infinitum
fifty years of labor relations
rust to scatter
in the matter of the mother
new to sleep but getting the job
done
shouldering what's left of the sky
over Dearborn's New
without the pert smile
of service rendered sensitive
to tinnitus
for the rest of us
I love the wheel and that is all
said Paul
holding his ears
to face his face
against youth devoured
in oncoming cars
Not that by then
they'd be any less stars

What's left of the sky then
when night falls and maybe
a hundred of us
gather to witness
the figment of my anguish
in the officer holding his ass
up to his ears
clearing his throat
of a certain cheerful vulgarity
None should take offense
though Pauline stoops
and the officer fingers
the knob in the very place where
orthogonals converge
at the barricades
of Absolute Disaster
coming after chords
lyric and vocal
"Daisy, ..."
unfurled at a safe enough
distance

And vocal, that is,
dying to be written
in the bossy imperative of the GPS we
exit the elephant already
in a snit
to beat the band
that waits and the kiosk
around the corner
where my message will be posted
in a future torn
from hot bacon and beans
We alight from our wagons
warm kids in tow
People all over the world (everybody!)
join hands (join!)
start a Love Train
and what this has to do
with cartography
before the horse finds a frontier to halt at
—Just go to edit
and press undo

The Love Train
had no idea it would end here
Least Algonquin last
American in a fit
of health sighed
in a haystack
for a to-go needle
No one could count
and none did
the red corpses tied nightly to women
who fussed and cared
Perhaps the podiatrist
would wander in here
and relieve us
of having nowhere to go
to
but perhaps not
after the lapse
of hither into thither
only to realize
we were not even close

We were not even close.
Daihatsu jetsam sailed
on nuclear steam
Of course there's no such thing
as thought streaming from the ear-
buds of those in distress
in this sense we're all managers
fleshy bodies
of fishes larger
than the lion supreme
paw raised
like a hood ornament
in mid-stride salute
can suffer
though the door closes after us
(Never cut to a door)
The great little dictator remains poised
in the needler's art
clueless
as to what we were
and what we were up against

LATE HUMAN

Compare, for instance,
The body, the brain, and its compost

Oak moths in hex prolix
Near the visitors' center, a bear

In the shelter of
A thousand two hundred and threescore devices

Connected via Leopard, Lion, Lamb
It is thus no accident

When the Haitian Berliner Philadelphian finds
One lives in no atlas but the head

And forty and two luddites on a pin revolve
Like an unhappy disk

And the mountains we had hoped to scale were not found
(Not found)

—An error we shall return to on another screen.
And this is just an overview:

If bauxite, then aluminum. Sentimental? Vietnam.
You'll know where it hurts and when.

Because we are the students of a great school of mice
Who'd march a mile and some to be with us

If they could if they cared if compost is an instance of ants
Fortified forward

It is we who are succulents
Adroit in the desert and miscible as much in our drinks

As in our culottes. Double unto double so I say
Do-able (if this is incorrect, press 1).

So it is in the story of two plagiarists (you, me, and the
 pharmacy)
After one fine day sitting down and standing up

As it happens, I am their musick [with a *k*]
And you, their tagline sliding

As feet in due time, so the next won't step
Into a dreadful pit in another world

Where sun don't shine or earth yield
And you find nothing unfine to stand upon.

How awful are the words "Run for your life!"
But somebody has to push them

Out. We are at present in a long wave
of stagnation—struggling at a dress

For which we are too old. Buster
The dog has once again misbehaved

But for that we do not become generals, for
As grasshopper we agree to be small

Huddle and cook
Under the robes of great odes

—The puttanesca was easy but not my fault—
Having peeled back the foreskin of your heart

Not that there were no imperfections attending that first patent
We simply meant to flatter 'em

And their crude Darwinism leaking of course
From our television, a GE set from the fifties

Pouring out its smoke and whiskey shtick
Syndicalism and wars

Of the world are not "normal" conditions, however;
For that we have had to walk 500 miles and

More to account
For the oaks in all states of this team of experts, Behold!

The wooden legs and deflated purses
Of the aliens of area 8

Performing teary oratorios
On largesse uncertainty and crabs

Polyphony in all the right places
Cues another queer day in the office

Of visitor pythons set to take Florida
And her birds in the perennial drinking up

Of Okeechobee. Name it now,
Soon, the bears whom we've unhanded

Move on to the California Polypody under a backyard
Oak and think back

To a good old-timey saw
Playing blueberry for Sal

But you don't have to call me *Darlin'*
When you see a long forever approaching, *Darlin'*.

You don't have to lift a finger to be
Ipso facto citizen of the reservation's unfunded

Conservancy. I hear what you need's
A hagiography; hell

They've got the jellos all lined up for us
And poor Father Time, who expires at last of his own inutility
 under a great mop of hair,

Rests, *ex post* in the pages of biological determinism
That's what Hardy says, anyway. And what about you,

Robert or Bob? Rosemary, John, and Isaiah?
Do we stand an odd dark Sunday? A hebdomadal assortment

Afflicted with incurable malady? "Is this not
The Public School?"

Yet I keep on and consilience is
Its own reward. Fruit! say the drivers when the race

Devolves, organized by fixers as an all too transparent
Scam. Sentiment then, and a well,

But barely enough to go around. Someone small's stranded
 down there
Whom we choose in the end to ignore. O well. Ah, well! Oh, well.

It struck me at Ichetucknee
That the state is not a spring though a spring may be

Inductive, the way I spout fire and increase
By cruising online for the next thing in large.

Though the car is at the door
And the driver a hesitant chauffeur

The birds flirt with your uncircumcized
Ear—stork, crane, and swallow—hard

At it, leaving the turtle to observe from the blind.
Leaving us. Desolate? Embarrassed? If our bottoms blaze up,

Why do we sit so still? Cool evening
Alone returns when fog can't ever at last be done. Whoever is dung

Is dung. Adroit in our duets
We were hostile until bed

Then all bent to enchantment and
Again we take up the cause, lifting and lowering our sets

On stiff chains, forests of bad actors unsure whether to advance
 or retreat behind equally
Misinformed mountains.

These are we.
Competitive, hungry, smug, unyielding.

Sore, branded, motor-mouthed, abandoned
People who do dishes for poor

Occupiers. Let us moreover consider back pain and front
A sobbing in the kitchen that belongs to the genre of

Are there no physicians here? Tackle and block—
Local as they are universal—are not louder than the snorting

Of Dan's horses just in from the Song of Himself
The he-birds and she-birds in conference

Denote a worried pair in a permanent
Wave of state, now burden

Now mind. The harvest is past, the summer
Spent. But we still have a few people to thank

Before our brave poem bends its way toward *H*
Or cashes out in Huertebise's basket (whatever's best in hand)

I'd rather be blind some she will opine
Than to see you with another ear

Prosthetically enlarged of course you are near
In the mouth when *¡hola!* we say

And far in the reins that refuse to fall
On the over-ripe overkill of the sandhills and Wichitas

(Land now estimated at 4.5 millions
Of revenue)

So I got myself a girdle but it was good for nothing
But a head of steam whose outflow had already aired

Its final reveal. Let us not forget the bear-cam broadcast
At eonic speeds against rhyme, accumulation

Of any kind save an occasional itch, catch,
Slow to the griddle because there was no grass under trash after all

To eat after A precipitous fall cannot emancipate us
A riddle unwise to the two hundred jillions

And I heard them we all did
Since we each were deep in the ink

Of our estrangement
The oak is a thing separate from us

From the capitalist and his undertakers
Many of whom are no doubt women

Bent to a surprise purpose in Maine. Steady rain
Gives way at last to the ghost oak made into a ship

For slavers descended as a relation between men,
Women, and things no longer apt

We sail away slack
In it hoping to be relieved of our partners

In the nitrogen industry yet not wanting
To rough it and keeping our underpants on

(We still had a pretty good time)
No through line

The tree just gets larger the more we cut away
No need to expand the brute logic

Of a still-warm evening purchased by a tax
On the mildly erotically disturbing balance on the sill

Of some *Nuits d'Été*
In the alienation of anarchy's affection for Berlioz's gift.

I think I'm supposed to take stock (steak?) and better face
It head-on, despite increasingly explosive material

Contradictions, a menace ridiculous
To a bear in the headlights unmoved

By wingspan anxiety, a citizen's whip or right,
Not between present and past but (between) actual

And possible wonderful
Feelings about intercourse with appropriate animals

And the upswing of popular indignation
Aimed squarely at their backs.

It has come to this and quickly
The bear wants to return as wandering disarticulated ears

Tingling in high cirrus on a handsome hundredscore
Family plans and no night

Cooks in their perpetual dusk kitchens
—But would that be so great?

And the yawning of books that cannot include us like *Crime
And Punishment*, *Thirst for Love*, and *Daddy*.

When the rose of the sun goes away color dips
To the gates of any city having devised a device against rising tides

And our indiscretions. Let the humming-fly and the musk-mouse
Scamper to their corners. Don't forget

Strange heat and clouds in the arena. Come,
Prides of lions to our refuge in Alaska

Three by three by three We shall not be hindered or dismayed
In an idiot wind in the pasture of

Butter the horse claiming We don't have to know anything at all
To grant the end however crudely foreshadowed

By howl, cry, and wallow The struggle no more with evil
Than it is with oil or us expats squatting in a reluctant
 rectangular circle

If you do the kale, I'll do the rice
No choice but to be useful!

And in seventy times sixty-seven years "The wind shall
Eat up all my pastors" for daring to skip around in the text.
 Don't forget.

The long waves are retrospective; short curves,
Discoverable. Come. The terror and the terrorist

Will be punctual. We said eight and it's now
quarter-to. Who

Let the dogs out must return them to their mothers,
For Buster has licked the chicken. Bare.

EARLY BIRD

The music had already begun

to disappoint

I can't go on

slaving for bread, sir

though sunup boasts

an egg in its fat

a worm in its skin

Clouds puff about all

matchy matchy

having begun the search

for tomorrow's chantey

janitors and senators

sensitive

to the way the world smells

when an old seadog walks

from the water weary and west

two oars

on her shoulder

And for how long

did you say?

For many things that are true

are just true enough

when oars drop

in The Nature Theater of

the pain and pleasure

of boredom

and this woke me

altogether more than I'd planned

the place being overwritten

by enthusiastic squatters

but this was later or before

and neither here nor really
experience

Capped by the haircut
along the top of the fence
pronounced as in French
together were we dead
or alive?
Progressive or curled?
Like the girl who cried the eyes
stark out of her head:
doctors without insight
sick opticians
sun minus future
rise and take a number!
The eventual
switchback is a portal
unguided unguarded
you have no choice but to stonewall:
Matterhorn of cream
on a pinnacle
of obstacles
so that every mouth
can be fed
an outburst of wool
in which all verse is blank-
ety Keep
the sun on your right
if you intend to go north
to chase a tune
otherwise

take a page
from my book:
inhabit memory's
stupid loops
in the middle marsh
on one leg
or the other exhausting enchantment's
tics
though talking of taking
the bull by the balls
unfairly
A wallet before and a wallet behind
signals a male with a large
repertoire says
au revoir to his close relations
who may be killing time
by keeping it Windswept
the post sweeps past
in the propaedeutic flood
giving the industrious fool
a leg up
over the 'possum
on the ottoman
of any old gal
hearing echoes
in the lapping of bills or doubles
the murder of terns
or their herring Over here
is the party
of bad translations
My oyster (the sun)

travels from red

to umber

but where is it

the bumblebee

ought to remember

to deposit

his aim?

As scavengers

it gets harder to distinguish

anise and fennel

promise and dismal

alive enough to so much

for the buckethead

(silly voter) to do

with a black goat called anything

but Red

imaginary emblem

of a real stick in the

near marsh where considerably less

than *full fathom five*

my father will sense sleight

audits

whether the road out ahead

goes uphill or down

and out Who wants to live

long takes a shot

in the chest If

the more one sings the more

she sounds

like many an army

and mockingbirds of course

have the advantage of being
fast learners

Were I you
and night long
only think
of the damage we could do
conscripted to sing
of ourselves in the first person
of the pines
That's progress, sir
when milk of the breast
goes good with a backlash
an east and a ghost
and yet I say sorely
tried and *terrified*
in letters couched
in full view of forwardmost and pale
regulars
If I put my point plainly
in a meadow
and who wouldn't?
For a way through college?
The right flank
unawares
lies corrupted in happy taverns
then culverts for a nap
Sun sets over handbills
perspicuous to Pickett
in retrospect
just a ticket

having again not yet begun
Point the way
Point away
tired to the point of waking
(no doubt in Wheeling)
to somebody else's tunes
on your own equipment
How came we
and whence?
Whereas earlier and crisp
a flat took only an hour to fix in Frisco,
Colorado—
Wish I were Wish I was
they sang
in the land hand-stamped
thereupon

Land
of getting on
If sensitive to sun
insert stone in shoe
place original whistle
on tablet or tome
in which it's nearly absurd for a bird
to be called even a momentary
nihilist
But that's the way
of the sentence
and our job to call a spade
a cradle
in the order of things feeling

Slow bitterns in grass
standing still as—*grass*?
I wouldn't if I were
in your poem
I'd raise my knee
to love unenhanced
under the sign of the rainbow
trout
I run out I run out I run out

Though worlds 'quit me, shall I myself forgive? At this
 hour??
Will it be windy or wet?
Is it going to hurt?
Can I have a soda? Are you really a doctor?
Can we keep our shoes on? Are you hungry? Again?
 Feeling tired?
Anxious? Depressed? You call this a martini?
Were real birds used?
Does wool bother you?
How's your French? What do you have for greens?
How about "Shady Grove"? Is that what I think it is?
Are you going to get better?
Do you think you can fool me?
Is there cash involved? *Who wants gum?*
Is it life threatening? Is she your real mother?
Did I call on you? Is this your stop?
Is that the cops?
Do I have time to squeeze my kidneys? Have you been
 crying?
Is that fair? What Marx would call "wet"?
Why didn't I think to call the air "floaty"?
Did you see the sky? Are you bowing or just tipping over?

Why do the males of some species sing so many different
 songs?

Do I hear free verse?

Sun as metonymy
re-arrives
fool enough, *arriviste*
You can do your anthropomorphic
bowing
to bring the oil up
(me too)
until we're both blue
to be fit
for survival Is it
enough you fool
to feel your face along
a steel-cut edge to
mornin' ma'am!
not a performance just
the way I am
in flight from
where I was in situ
wound about a wheel
"shirt me a-tear
up" after breakfast
in American poetry
comes lunch and then Apostrophe
and Stella striving

in the blue veins of a dry
lakebed hardly first or last
on the flyway (after me)
to aspire to the chronic
throat-clearing call
of a chirp
unheard from the train
by pickers, sorters, sisters, and such
as indeed
was the picture I found myself
sketched into

And now I would like to end in truth
lounging with my friends at Brennan's.
Of touch they are and poor
I am your straw
to be seen layered
as in a topographical drawing
at a bend in the river road
over which wheels wheel
that don't belong quite *there*
on the map
like the grin on my face
is mine but is
this a calm on the farm
with a finger to prove
what eye is this
that looks in my heart
and writes?
The wake-up lamp
simulates

2 Debussy and 1 Ravel

a century late and

out of control of course

but that doesn't stop

a hapless contingent

a squawk out of school

a big swim

a terrible march, No.

All my deeds

but copying is

hoard and tribute

to the Dr. Feel-Good

of Madame Seuss

at the end of the day

How long how well how simple

attention to sky is

when Blue Angels vie

unsecretly overhead

when

once a crowd progressed

(end to aftermath)

and I with great effort

showed you how mortis

and tendon could survive

a night drive

on the drunk bus

through the heart

of that stay-at-home Mélisande

of whom Pufendorf speaks

freely mourning her late crown

on a rock overhanging the cave

in which primitive fathers copulate
(on primitive nouns)
without fibrillation

It could not have come
at a better time
this mechanicianism or wish
by prior arrangement
with enlightenment
to roll Let's call it will
when you call about your
commas
I will always wonder
how to work the clock
in a place where sleeping babies
lie not yet named enough to
know not
to cave to gossip
still wet from the copulations
of extra pairs Theirs
are today's chores
Wish the good news
could be better
our treasuries and post offices flush
your herd animals more
along the journey road
to my facilities
than historical episode
repeatable, sore in fact
it was I who
carried the banner aloft

What imagination they said
flushed again and false
but not apposite
The fabled nightingale
took the pressure off
the life of us
who actually work the thing
is everything
begins with "re"
first instruction
matrimony
not mere conjugation
Well let's see
this might involve
a few phone calls
some serious math-astrology
by the trumpet rhetors
watching others read
"—a Jedi, he—"
O me, I might
live to see my eloquence explode
Stella!
inside and out
professional and technical
limits at once macho
and dainty
going from my hopeful natal territory
in search of multiple mates
opposing what is secret
outside any profession
of satisfaction

There I sit
ready to go
from my copybook
having learned the egg
costs more than the sperm or fatuous light
it was laid in
which about sums up
(sphincter-like)
the sovereignty of reason
its vulgar expression
by which I become
(sunsuit in transit)
completely incomplete
or modern.

NOTES

Deadpan

The epigraphs to the individual poems are based on rhymes recorded in _The Lore and Language of Schoolchildren_ by Iona and Peter Opie (Oxford: Clarendon, 1959).

"Who dat say who dat when I say who dat" — One of the many appropriations of African American vernacular in spoken English, _who dat_ was a routine used by US military radio operators during the second world war:

> I was in this shack by myself, tired and looking forward to being relieved so I could hit the sack, when I heard what sounded like a transmitter coming on the line. I said to myself "It can't be. No one would dare transmit or break radio silence on that channel." I then heard a voice say, very softly, "Who dat?" Next, another transmitter coming up to power and voice, a bit louder, saying, "Who dat saying who dat, when I say who dat?" Very soon the whole channel opened up with everyone saying, "Who dat?" and "Who dat saying who dat?" and the whole thing went crazy. It sure broke the tension.

> —Vernon L. Paul, US Navy, quoted in _The Silent Day: A Landmark Oral History of D-Day on the Home Front_ by Max Arthur (London: Hodder & Stoughton, 2014).

"Come out and take it, you [dirty] yellow-bellied rat!" — James Cagney's misremembered line in _Taxi!_, directed by Roy Del Ruth, 1932.

"Take care ... I bite" — Charles Dickens, _David Copperfield_, "Take care of him. He bites."

Where the Boys Are

"Monsieur le docteur Ralph" — the pseudonymous "translator" of the 1759 Geneva edition of Voltaire's *Candide*.

In Search of Lost Time

Spem — *Spem in alium* (Hope in any other), 40-part Renaissance motet by Thomas Tallis.

Hezzanith — Model of sextant produced by Heath & Co., an item of post-apocalyptic techno-waste noted in Cormac McCarthy's *The Road* (New York: Knopf, 2006).

Low Life

The title and epigraph are taken from the anonymously penned *Low-life: or, One half of the world knows not how the other half lives* (London, [1752]). The "Mr. H" of the epigraph refers to William Hogarth. This strange and wonderful book (and the capacity of writing to represent past reality) is discussed in Carolyn Steedman, "Cries Unheard, Sights Unseen: Writing the Eighteenth-Century Metropolis," *Representations* 118 (Spring 2012).

Late Human

"We are at present in a long wave of stagnation" — Ernest Mandel, *Late Capitalism* (London: Verso, 1976).

"Slaving for bread, sir" and "shirt [them] a-tear up" — from the 1968 Desmond Dekker hit "Israelites."

"Though worlds 'quit me, shall I myself forgive" — from Philip Sidney, _Astrophel and Stella_, sonnet 93.

ACKNOWLEDGMENTS

Many thanks to Kit Schluter and Andrew Dieck of O'Clock Press, who published *Early Bird* as a chapbook in 2014, and to the editors at *The Brooklyn Rail*, the *Cambridge Literary Review*, the *Chicago Review*, *Jongler* (Paris), and *The Claudius App*, where versions of some of the other poems in this collection first appeared. Sincere thanks also to Matvei Yankelevich and Ugly Duckling Presse for their support of this work.